YOU ARE HERE

YOU ARE HERE
*FOR NOW

A Guide to Finding Your Way

ADAM J. KURTZ

A TarcherPerigee Book

tarcherperigee

TarcherPerigee
an imprint of Penguin Random House LLC
penguinrandomhouse.com

Copyright 2021 by Adam J. Kurtz
Penguin supports copyright. Copyright fuels creativity, encourages diverse voices, promotes free speech, and creates a vibrant culture. Thank you for buying an authorized edition of this book and for complying with copyright laws by not reproducing, scanning, or distributing any part of it in any form without permission. You are supporting writers and allowing Penguin to continue to publish books for every reader.

TarcherPerigee with tp colophon is a registered trademark of
Penguin Random House LLC

Most TarcherPerigee books are available at special quantity discounts for bulk purchase for sales promotions, premiums, fund-raising, and educational needs. Special books or book excerpts also can be created to fit specific needs. For details, write: SpecialMarkets@penguinrandomhouse.com.

Library of Congress Cataloging-in-Publication Data

Names: Kurtz, Adam J., author.
Title: You are here (for now): a guide to finding your way / Adam J. Kurtz.
Description: New York: TarcherPerigee, Penguin Random House LLC, 2021.
Identifiers: LCCN 2020057428 (print) | LCCN 2020057429 (ebook) |
 ISBN 9780593192184 (paperback) | ISBN 9780593192191 (ebook)
Subjects: LCSH: Self. | Self-actualization (Psychology) |
 Self-help techniques. | Happiness.
Classification: LCC BF697 .K878 2021 (print) | LCC BF697 (ebook) |
 DDC 155.2—dc23
LC record available at https://lccn.loc.gov/2020057428
LC ebook record available at https://lccn.loc.gov/2020057429

Printed in China
10 9 8 7 6 5 4 3

Book design by Adam J. Kurtz

FOR YOU
FOR NOW
FOR EVER

CONTENTS

YOU ONLY GET
ONE LIFE AND
IT'S ALREADY
STARTED BUT
YOU DO GET TO
DECIDE WHICH
DIRECTION TO GO

\longrightarrow

INTRODUCTION

I've spent a lot of time as a person focused on getting through the hard parts. When you're in a dark place and processing complicated emotions or challenges, just trying to stay afloat makes sense. It's not always easy, but it's an easy enough plan. "Don't die." Okay, yes. "Don't quit." Right, good idea. "It gets better." So I've been told.

In my own lived experience, most good advice is rooted in the same concept: "Hang in there, baby," because "this too shall pass."

This book is not expert advice on how to be a person. If anything, this is me trying to explain that I didn't know what to anticipate of my life, and though I have since exceeded my very modest goals, I'm still figuring it out as I go. By managing expectations, by holding onto my core truths, by finding hope in possibility, and humor in the darkness, I have found a way to be okay. Sometimes people tell you that they had a dream from a young age, they didn't take no for an answer, and they manifested the sh*t out of it, so now they're the kind of person who says "Just believe in yourself!" and it feels like maybe they're

on to something. Please know that I don't feel like that person. All I've ever done is try to get through the parts I don't love and enjoy the parts I do, because I understand neither lasts forever.

Part of what makes things better in time is that you yourself get better. You grow into your own. You hone your skills. You learn to embrace who you are and find strength in that identity. A big part of my "problem" is that I have always been a loud, shy person who is bad at masking their emotions. It's very "look at me okay wait but don't," and then inevitably when you do it's too clear how I'm feeling about a situation. Over time and without other real options, I've embraced this about myself and tried to make it work.

Waiting for things to get better is part of the process of being alive. Time does heal many wounds. But it doesn't work alone. While I wish we all had the luxury of time, you might not. The opportunity you were hoping for might come sooner than you're fully prepared for. That specific chance might not come again. Does this make me a live-every-day-like-you're-dying person? Hell no. That sounds exhausting. And redundant, because as has been

well established, we are always slowly approaching death. Living in a frenzy is no way to live, and despite attempts at a perfect day-to-night outfit or a perfect New Year's Eve, no amount of staged photos and metallic number balloons can force a moment into a perfect memory.

There has to be a balance. Between waiting and preparing. Between growth and rest. Between living and curating. You can bide your energy while protecting it. You can research and practice while also acknowledging you won't fully know until you try. You may not have a plan, but you can plan ahead. Your most important role might be revealed only moments before it begins. In the meantime, you can be open to the idea and learn something from every experience along the way. Acknowledge that you both do and don't have a lot of time and then try not to think about it. EVERYTHING WILL BE SO GOOD SO SOON, JUST HANG IN THERE AND DON'T WORRY ABOUT IT TOO MUCH.

I wish that we all got the same pieces in the same order and could have unlimited time to arrange them. I wish I could give you the piece you feel like you're missing. Sometimes that's almost what advice is,

someone else thinks they can see your puzzle so clearly and is desperate to just give you the answer that worked for them. But life is weird. We're the same but different. Things are unpredictable. The patterns are there but the recipes are all "to taste," and so while learning from family helps it's not a guarantee. If you haven't been told exactly what to do, it will take trial and error. If you follow exact instructions, you may find that your taste varies. Either way it's a whole lot of muffins to get through, and then maybe you realize your life was meant to be a cupcake all along.

If you're extremely patient and do almost nothing else, change does happen. Inching along, gradual shifts in culture around us can bring positive impact to our lives. "Hang in there" often works. But if you want a head start—whether you're impatient, need practice, or feel time running out—you may need to effect that change for yourself. You can absolutely bake on low but you'll end up with soft edges unless you turn up the heat. You can change your own world, altering both the ingredients and the method for a head start on whatever pastry you've decided is your future.

The world is big and you will spend a lot of time in it. Some people get a hundred years, others get thirty, and in both cases that's their entire lifetime with no stopping. Waiting for things to improve is sometimes as much as any of us can muster. But time is moving forward throughout. If you get comfortable in the waiting, if you wait too long, if you're picky as you wait for the perfect variables and your most confident and secure self, ready to tackle only what you are fully prepared for, you may end up spending more time than planned. In our baking metaphor too much time in the oven and you'll get burned. Now you're carefully scraping off the edges or drowning everything in icing in hopes that nobody else notices.

The good news is that they probably won't notice. We spend a lot of time worrying about what other people are thinking, concerned that they can tell we are freaking out inside, feel underprepared, or don't know what we're talking about. Most of the time, people are so preoccupied with some combination of the same fears that they don't have enough time left to psychoanalyze a person they just met who replied, "Thanks, you too!" when they've

said "Enjoy your latte." You have dodged a bullet, and in fact the bullet doesn't exist at all. Everyone is awkward. Everyone is scared. Everyone is going to die eventually. Everyone just wants to make some friends and memories before that happens. Everyone is trying to figure it out.

You only get one life and it's up to you how to live it. You might be focused on travel and discovery. You might be focused on social impact. You might be focused on innovation for the sake of curiosity or wealth or both. You might be chasing fame (as a general concept) or recognition (as a result of great achievement in your industry). You are different from me and your internal motivation will be your own.

Your experiences have shaped you so far, helping mold you into exactly who you need to be to approach the challenges that arise, in a way that only you can. You may not feel ready. You may get it wrong. You may get it right and then five years later see clearly that there was another path you totally missed. But inaction is action too. You are moving forward regardless. All roads lead somewhere, and in life all we can hope for is a long,

beautiful ride, but it's always a dead end and that's kind of the point?

This book may be a guide, a reminder, or a well-timed suggestion. Read it in any order (though I get more personal as we become acquainted). Pick a phrase to internalize forever or forget it immediately. Flip through the art and reflect on all the bending and folding you've done to become who you are. Breathe in, out, and through. Tear out a page you love. It's all just paper. This book is yours.

The past is behind you and the future is coming soon. You are here.*

*For now.

YOU CAN TRY TO
ORGANIZE YOUR
EXPERIENCE BUT
YOU CAN NOT
ACTUALLY CONTROL
TIME ITSELF

TRY TO ENJOY
MOMENTS OF REST
WHEN THEY COME

THE WAITING
IS PART OF IT

THINGS WILL HAPPEN
UNEXPECTEDLY
AND YOU MAY BE
IMPACTED IN A WAY
YOU WERE NOT
PREPARED FOR

*THIS IS ACTUALLY
EXTREMELY LIKELY

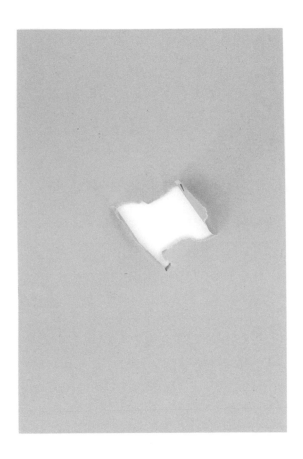

YOU MAY FIND
YOURSELF FORCED
TO ADAPT TO THE
NEW REALITY
DESPITE BEING
CHANGED IN A
FOUNDATIONAL WAY

THE IMPULSE IS TO
WANT TO "GO BACK
TO NORMAL," BUT
THIS ENDLESS
ADAPTING IS
NORMAL

YOU MAY REALIZE
THAT THE WAY
FORWARD IS TO SHED
OTHER PARTS OF WHO
YOU THOUGHT YOU
WERE OR WHAT YOU
THOUGHT WAS
IMPORTANT— TO
MAKE SPACE FOR
NEW INFORMATION
OR IDENTITIES

WHILE IT'S TRUE
YOU DON'T HAVE ALL
<u>THE</u> TIME IN THE
WORLD, YOU DO HAVE
ALL <u>YOUR</u> TIME IN
THE WORLD

YOU HAVE LITERALLY
YOUR ENTIRE LIFE
TO LIVE WITH YOUR-
SELF, TO ADAPT,
AND TO ACCOMPLISH
GOALS

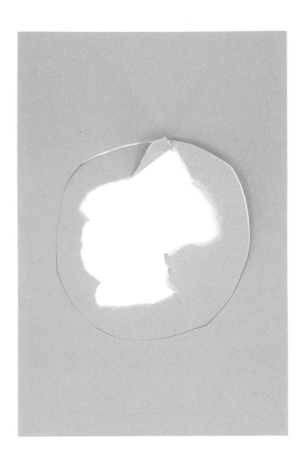

THERE WILL BE A LOT OF ADAPTING. THERE WILL BE A LOT OF LETTING GO. IT IS SCARY BUT NECESSARY WORK TO MAKE, DO, AND MAKE DO IN THE SERVICE OF BECOMING A VERSION OF YOURSELF YOU CAN FEEL CONTENT LIVING WITH. RELEASE THE BAGGAGE, YOUR SCARS WILL BE REMINDER ENOUGH OF THE LESSONS LEARNED IN THE PROCESS

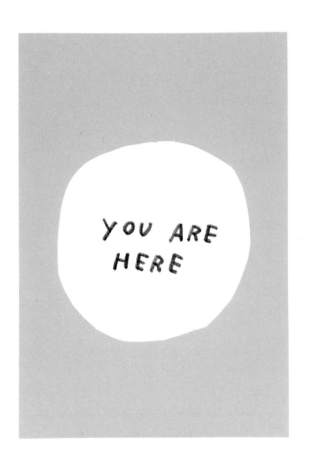

YOU ARE HERE

*FOR NOW

TIMING IS EVERYTHING

You can have all the right pieces, do everything correctly, and be as prepared as you'll ever be, and things still don't seem to be happening. Unfortunately, you just have to be patient.

People love to attribute success to hard work, and that's a huge part of it. Most things don't happen by accident and are the product of effort. But so much relies on good timing, whether that's being in the right place at any given moment, being uniquely positioned for an opportunity, or just connecting with another person at the exact right time for them, in their lives, too.

As someone who always wants to have a plan and know exactly what's happening, this timing thing can be a hard one to come to terms with. For me, punctuality is important, even when it's not especially serious. I'm the guy who throws a party that starts at 8:00 but starts peeking out the window at 7:55 to see where people are. I have to remind myself that people don't come to parties on time and that in many social situations, I should actually show up a bit later if I don't want to come across

as overeager, or even rude. I am someone who, usually for no reason, is walking quickly enough that people assume I know where I'm going. This often presents as confidence or familiarity, to the degree that for a while, I couldn't shop at an Urban Outfitters without being asked where the dressing rooms are (they're upstairs). All this to say, time matters to me even when it doesn't actually matter to anyone else involved.

Relationships are about timing too. How many of us have been "ready for a relationship" and put ourselves out there, done our best to be available, met someone, thought it was going well, and then suddenly . . . it's not. "It's not you it's me," they say—you're great but it's just not clicking—and there's nothing we can do about it. Every connection, whether it's romantic, business, or friendship, is all about us meeting at particular moments in our lives when we're ready, open, and have had enough of the various experiences we needed to have previously, in order to bring us to this one, at this point in time, together, and have it stick.

It's hard to have patience, especially when you aren't actually sure what you're waiting for.

Have you ever felt ready for the next thing, but not sure what that thing is? Have you felt homesick for a place you haven't been yet? Maybe a deep sense of longing for a version of yourself that's never actually existed but feels extremely possible sometime? Have you felt a deep yearning for a cool, collected, mature future self that was so palpable that it actually hurt your chest and you wanted to crawl out of your body so your soul (or whatever) could make a run for it? Just me?

I want to tell you that eventually your dreams come true and you arrive at all the things you were waiting for, but you might not! Your destination changes because it was never a place, and your dream comes true but it's a different dream now. Life informs who you are and what you want, and so the Past You that dreamed a Future You couldn't get the details right because they hadn't materialized yet. You couldn't goal set or plan or work toward the exact version of what you thought you wanted because you didn't know that you'd know what you do know now. But you have to believe that eventually life will sort all of it out, and it might not be what you imagined, but it'll be right at the time.

IT'S OK TO NOT KNOW

You'd think that as a person who supports himself and has navigated life so far without dying that I might have more of a grip on things. What I'm doing (right now but also in the future), how I'm doing it (the tools of the trade but also a larger plan), and where I'm going (creating a home but also career goals). But honestly? Nope, no, and not yet. I did what felt expected of me at the time (finished school and earned a "practical" college degree) and then entered into real life at twenty years old ready to have life mapped out for me, which of course it wasn't.

One of the first things I did in my early twenties was GET VERY SAD AND SCARED, which I don't necessarily recommend for you as a step on the journey but understand might already be on your list anyway (bonus points if you're sad and scared right now). This was not 100 percent my fault, but I had several traumatic things happen to me in a short span of time. If you can avoid it, maybe don't get in a car accident and mugged at gunpoint in the same month.

At a certain point I just embraced the fact that life is surprising. You're about to leave for the weekend when you crash your friend's car. You're strutting to work listening to Rihanna, and then two guys push guns into the back of your head and steal your pink iPod (it was a different time). It's not all bad, but some of it really is! So the answer can't possibly be aggressive planning. I decided to embrace little-to-no planning and just do my best with what I had at any given moment.

Disclaimer: Not knowing what you're doing isn't the same as not trying!

I spent so long wondering what "my path" would be like, where it starts, and how I would follow it. What is out there for me? What or who is waiting for me to find it or them? One thing that has become clearer to me as I get older is that there *is* a path. I simply couldn't see it until now that it's behind me. There's been a path all along and I've been on it, with clear markers and pivotal moments that led me from place to job to relationship to insight to milestone. My path exists but it's not linear and I can't see too far ahead.

Work to create a safety net of tools, skills, relationships, and resources that keep you open

to possibility. Look to yourself to create new opportunities when you can't find them anywhere else. I've realized that while life is unpredictable, patterns do form. I can anticipate and prepare for recurring moments: birthday depression, slower periods of work availability, seasonal allergies, and tiny surprise fires to put out that can occur at any time. Sometimes the "tiny" surprise fire is a global pandemic that severely impacts every element of your life and the lives of everyone around you. Surprise!

Not having a plan isn't the same as not planning ahead, which you can do in a broad sense in whatever ways might be available to you. My suggested Non-Plan Plan is as follows:

1. Save for the future.
2. Protect your relationships.
3. Pay attention.
4. Form healthy habits.
5. Learn new things.
6. Consume art in all forms.
7. Be kind to others.
8. Be kind to yourself.

I literally do not know what I am doing, but I know how to make that feel okay. You can't control anything or anyone but yourself, and the earlier you embrace this as truth, the easier it gets. If you don't know where you're going, just keep preparing for anything and be open to possibility. Your next step might be sooner than you think.

I LITERALLY
DO NOT KNOW
WHAT I'M DOING

THE ANSWERS

There's a part of me that has, for a long time, believed that everyone else knew something that I didn't. It seemed like there could be a set of rules or guidelines or principles known to humankind that I wasn't yet privy to. For lack of more accurate language, maybe we can call this "Enlightenment." I have been eager to arrive at it.

Life would make so much more sense if someone would simply give me the pieces to navigate the Structure of Everything. I personally feel I'd be a great candidate to receive this information, because I don't believe in a scarcity model and I can't keep my mouth shut—I'd share this knowledge with the world in simple and accessible language to as many people as want it, and we could all thrive. My book wouldn't be *The Secret*, it'd be *The Answers*.

Unfortunately, this hasn't happened for me yet. People I was sure had reached Enlightenment in their lives turned out to be as scared as I am. Wise men I once respected disappointed me when revealed as human. The secret, it turns out, is that there is no secret or at least there isn't just

one. The answers, meanwhile, do exist and are somewhat standard (with some discrepancies for variables like identity, geography, time, networks, and chance).

Below, an incomplete list of all the answers I've compiled in my life so far. This list is provided as a reference "For Entertainment Purposes Only" and should be taken with a grain of salt. Neither Adam J. Kurtz (d/b/a ADAMJK® LLC) nor TarcherPerigee, an imprint of Penguin Random House (or its affiliates known hereto or in the future) are responsible for the accuracy or validity of these answers as applied to your own life. Do with them what you will:

No, Absolutely, Yes, but it's actually love (which you maybe knew), Unfortunately not, Water, Yes, but probably not in the classic sense, That's up to you to decide for yourself, 42, Not without some effort, Slowly inhale through the nose hold your breath for a few beats then exhale slowly through the mouth (repeat), You deserve to try, Yes, Probably, People usually don't know unless you tell them, I wish, Love.

WE KNOW
THE ANSWERS

WHAT IS THE
QUESTION???

EVEN "GOOD ADVICE"
IS INTRINSICALLY
SUBJECTIVE

ACCEPT IT AS
SUGGESTION
AND FORM YOUR
OWN IDEAS

MOST OF THE
TIME THE ONLY
"MAGIC CURE"
IS SLOW AND
STEADY SELF-
IMPROVEMENT

"SUCCESS"
IS NOT
ONE THING

"SUCCESSFUL"
IS RELATIVE

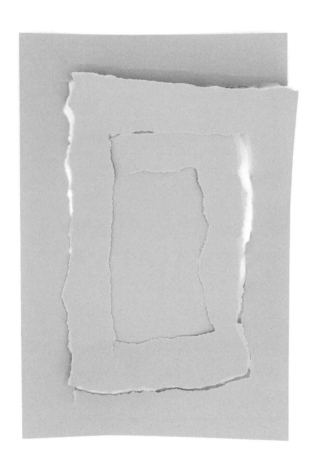

"OVERNIGHT
SUCCESS" IS
VIRTUALLY
NONEXISTENT

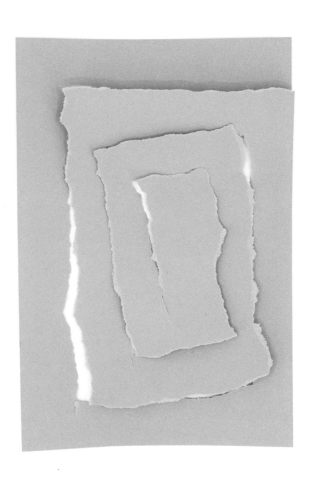

"SUCCESS" MIGHT
JUST BE DOING
YOUR THING
YOUR WAY AND
HAVING THAT
BE ENOUGH TO
FEEL CONTENT

THERE IS A LONG

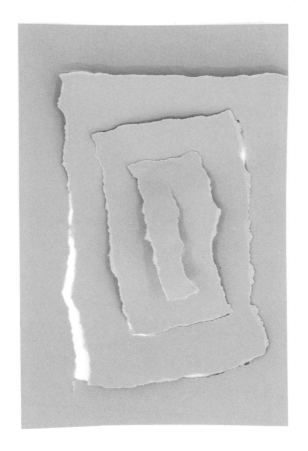

JOURNEY INSIDE OF YOU

BEING BUSY IS NOT A PERSONALITY

A lot of us have a lot to do. That is completely valid. We're juggling work, which might be one job, many jobs, a "day job" and a "side hustle," or any number of ever-changing combinations.

We're bettering ourselves, which might be school, or courses, or studying a new trade or skill. We're taking care of ourselves, which is everything from lighting a candle to lifting heavy things repeatedly until our arms are big. We're helping care for loved ones, we're maintaining our relationships, we're raising children, we're trying to enjoy nice things sometimes, or go on a trip. We're cooking meals, we're reading a book, or maybe three books, but one is fiction and one is nonfiction and the third is just short essays so it's not a big deal. We're catching up on that show that keeps almost being spoiled for us because everyone else already saw it. Individually none of these things seem extraordinary, but combined they become the days and weeks of a lifetime.

We are busy people! Life demands we work to live, life requests we work more if we want more of the fun stuff, and the fun stuff demands we keep going for "just one more" drink or episode or hour or mile. This isn't inherently bad, even when it is exhausting.

Everyone is busy in their own way. Being busy doesn't make you special, being busy doesn't make you more important, and being busy is definitely not a badge of honor. Being busy isn't a sign that you are more productive. Being busy doesn't signal that you are more valuable or more worthy. You might be busy, but *being* busy isn't a single, tangible thing and it's definitely not an entire personality.

Being busy isn't an excuse for why you're being an assh*le right now. Being busy isn't really an explanation for why you couldn't text back eventually. Being busy doesn't negate the fact that you didn't do that one thing you were tasked with and now everyone else has to pick up the slack.

Sometimes, "busy" is shorthand for something else, in the same way that "tired" can mean anything from physically exhausted to extremely depressed. But people who are always busy when you need

them? People who enter in a hurry and run out just as soon? People who are here, but just have to hop on a quick call in ten minutes? People who text through an entire meal? These people aren't just busy, these people are rude.

We all have things to do. We all have expectations to manage. Letting someone know that you're strained or overbooked or extra-anxious right now is one thing. Letting someone know that you're too busy—and at the very last minute, of course—means that you didn't plan and also don't want to accept responsibility. And so maybe being busy is a personality, but it's not an aspirational one.

If you're someone who's always busy, maybe ask yourself to dig deeper. Why are you so busy? What's going on with you right now? Are you juggling a lot of stuff? Are you spending a lot of time cycling through periods of intense productivity and then dealing with the inevitable crash, then doing it all over again? Are you temporarily working extra hard toward a specific goal that keeps moving further away? Is a work environment intentionally draining you of your time and energy out of disrespect for you as a person? Are you distracting yourself?

Some of us don't have a choice. Some of us are dealing with a specific situation that requires us to be truly busy at any given point in time. I sincerely empathize with that, and if that's your reality right now I am sending you strength and luck that you can navigate everything and find your way through to the other side. But for those of you who see being busy as a goal, a status to arrive at, and an entire identity, please stop. Get to the root of what this is all about for you. Pick apart the layers of "hustle harder" and "rise and grind," and every other bit of advice you've internalized just a little bit too hard from a certain kind of inspirational industry figure, and let it f*cking go.

Being busy is *soooo* over. Anyone can be busy. You know what actually is a personality? Being calm, cool, and collected. There's nothing more aspirational to me than someone who can either make the time or knows how to politely decline as needed, so that they can let themselves enjoy the benefits of their hard-earned success.

YOU ARE NOT IN COMPETITION WITH EVERYBODY ELSE

We know that comparing ourselves to others hurts . . . because most of us have been doing it our entire lives in one way or another!!!! Yes, creating structure is an important part of success, and one easy (and lazy) way to define goals is to track our personal progress against others. This happens in school, at home, in the workplace, and is constantly replicated throughout life.

When working on yourself, it feels natural to default to this old classic, to identify our "competition" and then work to "beat" them in grade, rank, or whatever else. But comparing ourselves to other people from a distance on everything from physical ability to job opportunities is never going to be truly useful or effective.

When looking inward, you can know the whole story. When it comes to others, there are huge gaps. There's too much about individual journey and motivation and resources and progress that we don't and can't know. Even if you do have insight

(such as "healthy" competition with a colleague or teammate) there's still so much that simply doesn't correlate directly.

It's in our nature to look to others for signs, inspiration, insight, or direction. I look at people just walking around with a fashionable outfit or whatever and I'm like, "wow I wish I could pull that off," and I let these smaller comparisons weigh me down. I'm not as strong. I'm not as smart. I'm not as cool. I don't have the same resources. This kind of thinking is extremely human and (unfortunately) pretty common.

You're not a bad person for comparing yourself to others. You're not a bad person for measuring where you are against where you're not. But you deserve better. Comparing yourself to others seems useful, and maybe feels good when you're "winning" but hurts even more when you're not. Either way, it's a false equivalency that doesn't yield any kind of practical metric.

You are not in competition with everybody else! Life is not a race or a contest! The only things that are races and contests are races and contests. Everything else is a solo journey that may overlap

and intersect but is unique to your experience. The competition model wants us to believe that only one person can ever win, that only one person will be Number 1. Please, for your own health, success, and sanity, let go of this idea. Don't buy into this structure that you didn't create for yourself. Don't adopt someone else's method and then use it to beat yourself down. I know you know this! But there are so many external influences that lead us to forget.

Social media in particular shapes reality into something that feels competitive, because not only do we work to present the most idealized version of ourselves (or at least a specific version) we then opt in to real-time judgment: A system of likes and comments that purports to confirm or deny our "content's" inherent worth in a way that we all understand is negative and even harmful, but also doesn't stop us from paying attention. It can almost feel useful to keep tabs on others, drawing comparisons or any other false correlation we may seek out in order to inspect ourselves. Maybe you're a better person than I am, but I definitely notice. To adopt the language of the internet, I know when a post is a "flop" and it's hard not to feel it. A piece of my life that I prepared

for consumption has flopped, therefore I am a flop. Nobody stans a flop.

If you can't relate to this example, honestly, bless you. But for many, it's a frequent reality: Unsolicited measurements from a system that can't ever speak to our individual value, and in fact prefers to group us by category and filter us through an algorithm so they can serve us up to advertisers. The immediacy of this whole process makes the false equivalency plainly obvious. You can't compare your friend's baby (59 likes) to a stranger's pizza slice (234 likes). You can't compare your creative work (566 likes) to an extremely popular video clip of a potato tied to a ceiling fan (so many views that half of you know exactly what I'm talking about and the song is in your head right now). None of these are reasonably comparable. None of us are in competition, no matter how much the social media ecosystem wants us to think we are.

Any time you find yourself comparing your thing to someone else's, stop and ask: Who told me that my situation was comparable to this person? Who determined that we have the same skillset or resources? What makes me feel like this is a valid

metric for measuring my own success? Why am I doing this to myself???

Compare yourself to your best, and use that to fuel yourself forward. Push past your own limitations in the ways that you can, at the pace that you can manage. Define success for yourself, set your goals, and then keep pushing beyond them. Celebrate the achievement and move the goalpost a little bit further. Take it as far as you can go, for as long as you feel like going. Then take the win. It's yours alone.

IF AT FIRST YOU
DON'T SUCCEED,
CONGRATULATIONS
WELCOME TO LIFE
IT IS HARD SOME-
TIMES BUT ALSO
MOSTLY OKAY

GREAT DISPLAYS
OF POWER
ARE OFTEN
SURPRISINGLY
QUIET

IF YOU COULD
STRIP AWAY ALL
YOUR DISTRACTION
AND OBLIGATIONS,
WHO WOULD YOU
BE LEFT WITH?

PRODUCTIVITY IS
NOT PERSPECTIVE
UNTIL MUCH,
 MUCH LATER

WHY ARE YOU
SO BUSY?

WHAT ARE YOU
WORKING TOWARD?

WHAT ARE YOU
MISSING?

WHO TOLD YOU
THIS WAS VALUE?

BEING BUSY IS NOT
A PERSONALITY

BEING BUSY IS NOT
A PERSONALITY

BEING BUSY IS NOT
A PERSONALITY

BEING BUSY IS NOT
A PERSONALITY

BEING BUSY IS NOT
A PERSONALITY

PEOPLE MAY
HAVE THINGS THAT
YOU DON'T HAVE

THIS DOES NOT
MAKE THEM "BETTER"
THAN YOU

COMPARING
YOURSELF TO
OTHERS IS NOT A
USEFUL METRIC
UNLESS EVERY
VARIABLE IS
IDENTICAL...

WHICH WILL NEVER
BE POSSIBLE

IT'S POSSIBLE TO CREATE
STRUCTURE WHILE ALLOWING
YOURSELF SOME FLEXIBILITY.

FAILURE IS JUST RESEARCH UNLESS YOU NEVER TRY AGAIN

For many of us (me) the hardest part of trying anything is feeling like it's going to be difficult. We are lazy. We are tired. But mostly, we are afraid we won't be good at it, and then we will fail. We will fail and not win and be bad and everyone will know it, and we will know it, we will have quantitative proof of an attempt being made and not being good enough. Maybe it will be private but maybe it will be very, very public and everyone will see the fail in real time. Oh god, maybe it will be a big fail. An EPIC FAIL that is so LOL that it is remembered forever. Better to keep it small. Better to keep it private. Better to never try anything you're not at least 99 percent sure of, just in case.

But—hello, hi, yes—failure *is* an option. Failure is one of two main options in most scenarios. Failure happens. All the time. Constantly. I have failed so many times in my life to do all sorts of things, from things I thought I really wanted to do (get accepted into a special program for advertising creatives) to things I only sort of wanted to do (an extremely

steep hike I quit halfway through). Failure isn't the end. Failure is part of the process of accomplishing a task. In fact, the only time failure is truly final is if you don't use what you've learned through the experience to try again. Each attempt becomes an experiment, each failure provides valuable insight and pinpoints room for improvement, and then eventually (maybe soon, maybe not) you get it right.

At this point in the self-help book I would like to discuss the literal mountain I tried to climb, because anecdotes are helpful and because we can create meaning in our own lives by leaning all the way in to obvious metaphor and pretending to be the hero of our own story (which of course each of us is). So the mountain:

I've spent every Christmas since 2014 in Hawai'i, not because I love warm weather and being outdoors but because my husband is from Honolulu and we spend the holiday with his family. There are parks and trails all over the island of Oahu, and those who love to hike are rewarded with endless blue sky views, stunning hidden waterfalls, or at least "a sense of accomplishment" for their efforts. I don't totally get it.

A few years ago, we met up with some friends for an easy hike, the Diamond Head Summit Trail. Famous as a tourist destination because it's part of the iconic Honolulu skyline, its proximity to Waikiki Beach, and because it's an objectively easy climb, I quickly agreed. We didn't bring water bottles or anything because it really isn't very difficult, more of a cute walk and then maybe we'll get shave ice when we're done.

We drove to Diamond Head and immediately realized there was no parking. In retrospect, going to a massively popular tourist attraction on a Saturday afternoon during the busy holiday season wasn't a great idea. None of us wanted to wait in the car, but we definitely, for some reason, wanted to hike right now. A quick judgment call was made, and we decided to go to the Koko Crater Trail instead. "No big deal," explained my friends, "because there's a staircase built right into the mountain! Let's just go! It's not that far!" I agreed (because now I wanted shave ice).

What I learned is that the hike up Koko Head is a three-quarter-mile climb of one thousand and forty-eight steps straight up the side of a mountain in

direct sunlight. The steps are made from old railway tracks and cinder blocks, broken or missing in pieces, jagged like skeleton teeth, and without anything to hold onto but the next step up. In some parts of the climb, missing a step means dropping down onto rocks. Hiking is awesome and I love to hike! We began our trip, and I did as well as expected, which is to say I made it just over halfway before I thought my heart might explode. I was sweating profusely and had already needed more than one pause to rest by that point. I was genuinely concerned that I was going to have a heart attack or at least pass out. So I did some mental math and decided that the reward ("a nice view" and "not being embarrassed in front of my friends") was not enough to maybe die for. I turned around and spent the next thirty minutes catching my breath in some grass near the parking lot.

At this point, the hero of my story (still me) had undoubtedly failed in the most literal sense. I was aligned, then declined to climb the incline—and everyone knew it. I did not get to be in the group selfie at the top. I did not look at the ocean and feel humbled by its beauty and a sense of personal accomplishment. I was embarrassed by my lack of

physical and mental strength. But mostly I was alive, which felt like the right choice.

A full year passed in which I accomplished many things. I received accolades and recognition for my work. I enjoyed the fruits of my labor. But I had not climbed the mountain, and even though nobody else cared, this failure continued to float in and out of my brain. I turned an actual mountain into a "mountain of the mind" by crafting a story of my physical and mental limitations, wrapped up in a narrative of failure and weakness that could only be escaped by reaching the top next Christmas.

So, using everything I'd learned the first time, and after a year of thought, did I climb the Koko Head Stairs? Does it even matter?

Yes, of course it does. Oh my god. Imagine if this ends with no sense of accomplishment. Yes, I climbed the f*cking mountain! Not because I was in better physical shape. Not necessarily because I was in any way a stronger person than before. I climbed the mountain not through sheer willpower, though I had plenty. Instead, I took everything I learned from my failure and used it as research for a successful second attempt.

I wore more appropriate shoes. I brought a full water bottle. I brought a small towel to wipe my forehead. I went in the morning, when the weather was cool and the sun wasn't yet in peak position. I climbed the mountain and I didn't cry at the top, though that would have been beautiful. I climbed the mountain and felt pride and gratitude, as much from reaching the top as from vanquishing the mountain in my mind forever. I was enough all along.

This challenge didn't require an "Eye of the Tiger" training montage. Honestly, I didn't change a single thing about myself. All I did was make a few easy adjustments to the situation and try again.

Failure is scary and it comes in all forms. Sometimes the mountain is bigger than a mountain. But ultimately, most can be climbed. Take your time. Wear the right shoes. Bring some water. And when you make it to the top, try to catch your breath before the big photo.

NOBODY IS WAITING
FOR YOU TO SCREW UP

The speed of the internet has created a sense of pressure in me to create and share new work, words, ideas, or whatever level of art the average tweet might be considered, constantly. I know I'm not alone in this endless need to be present and counted in one way or another through a contribution to the "global conversation." As a result, I often find myself trying to squeeze dirt into diamonds to throw into the void. These contributions rarely shine, most of the time it's more like tossing clumps of dusty earth that disintegrate midair, and if not, land with a barely perceptible plop into nowhere. They exist unnoticed, or hardly noticed, for an hour or a day, and then I delete them. Unless, upon reflection, that plop still makes me laugh. Then it stays.

This low-level panic to say something or make something doesn't feel healthy or particularly useful. Even when I contribute something positive, it's still like . . . "okay, thanks, cool." But what I have found valuable in the experience is the

understanding that, actually, nobody is waiting for you to make a mistake. Nobody is holding their breath eager to catch you making bad art or saying the wrong thing. In fact, most of the time, nobody cares at all because they aren't paying attention.

When asked about the "bravery" I "possess" that allows me to share art (that might not be good) and insecurity (that might be perceived as weakness) freely on the internet, it honestly boils down to one thing for me: nobody cares.

We spend so much time worried about what people will think about us if we mess up. "Oh my god am I going to be publicly humiliated? What if I share this thing I made that isn't perfect and everyone figures out that it's not perfect?" Fair questions to ask, and nothing embarrassing about asking a question in the safe confines of your own brain. But in actual practice, in real life, nobody is standing by awaiting your failure. Nobody is really going to hold it against you if you can't draw an anatomically correct human hand. Nobody cares if the lattice work on your apple pie is ugly. Nobody cares if you don't know the right answer at exactly the right time.

Yes, this is an oversimplification. Some people might care. You might care. For a minute. For a day. Those dirt clumps I threw into the void are suspended somewhere in space and a few people might see them. Somebody will notice. But then, it will be over. It will be a thing that happened. The pie is still a pie. We love pie! You are still a person who is good at a lot of things. You are still a person who will do other things, or even this one thing again (maybe much better on the next try). Ultimately, time moves on, everyone keeps going, and you will be free to make more mistakes and get more things wrong in the future.

Everyone is living their own life, facing their own challenges, preoccupied with their own tasks and distractions, and even the people who do care about you also have a lot of other things to care about. So while a failure or mistake might feel hugely important to us, and that feeling might be valid for now (or for a while), everyone else is largely focused on the next thing. You are now free to do the same.

YOU WILL WRITE

YOUR LIFE STORY

1 Page AT A TIME

TRY TRYING

* IF THAT
DOESN'T WORK,
TAKE A BREAK
AND THEN TRY
ANOTHER WAY

IF LIFE WAS EASY
IT WOULD BE
EXTREMELY BORING
AND YOU WOULD
NEVER GROW

FAILURE IS
JUST RESEARCH
UNLESS YOU
NEVER TRY
AGAIN

NOBODY ELSE
WILL CARE AS MUCH
AS YOU DO AND
THIS IS OFTEN
A BLESSING
IN DISGUISE

AS SOON AS WE
REALIZE THAT IT'S
NOT OUR JOB TO
BE PERFECT,
EVERYTHING GETS
EASIER AND MORE
HONEST AND MORE
TRUE

IT CAN BE COMPLICATED
AND STILL BEAUTIFUL

YOU CAN DO IT (PROBABLY)

You are essentially a pile of bones and mush thrown into a skin bag with a face. There is no reason that you, a bunch of lumpy pieces, should come together and work. Literally at this very moment a bunch of gross parts are working in tandem to scan these shapes (letters) and combinations (words) and translate them into cohesive information that you can digest in your brain, and it all happens near instantly. I'm not a scientist but I think I can speak on behalf of the entire scientific community when I say that in some way, on some level, you are magical.

Most of us don't spend too much time thinking about how the basic elements of our lived experience come together. We take it for granted, because it just "is," or because thinking about it for too long can start to feel stressful. But honestly how does this all come together? Why can your skeleton move around and do stuff? Where are we in relation to the moon and planets and universe? What's the point of it all? Is there a god? Oops, too real!

Let's dial it back down for a second. We are here, in towns or cities, in countries, on a planet, in a solar system, in space. These are facts and we can think about them without spiraling into a full-blown existential crisis. More facts: We are bodies made up of bones and organs and tissue, and it all comes together in a package that can actually be quite attractive and do things like breathe and move and communicate. Some bodies can run very fast or carry heavy things. Some bodies innately move to the rhythm (though others definitely do not). Some bodies can literally produce other bodies! It is both incomprehensible and happens a thousand times a day.

Why does this happen? How does this happen? Sure, science. Science is real and science explains the possibility and truth around our existence and the existence of things around us and the existence of things long gone and the existence of things that may come to be. But just because we understand *how* does not mean we understand *why*. The why is part of what feels like magic. Why do any of us need to be here? Why do any of us do anything? It is truly wild.

All this to say, you are here ("for now," as established). You are alive. You are breathing and reading and moving and making and doing and sharing and being. Every single day you are essentially living a miracle, defying odds, and doing things that might be explainable but are still kind of phenomenal in the grand scheme of the universe. Which is why I can say with some level of certainty that you possess power. Innate, deeply rooted, human ability. You possess the imagination to define a dream, the intelligence to conceptualize each step, the resourcefulness to find the tools you need, and the inner strength to keep trying.

You're already doing magical things and defying odds. This whole being-alive thing is slightly mind-boggling if you think about it too hard (which again we are *not* doing). And all this is how I know, with a degree of certainty, that you can do it.

You can do it! You can do it. Whatever it is. You can accomplish a task that feels impossible to you now, because everything else you're doing should be impossible too, but isn't. You can get through this difficult time because you have defied the odds after a hundred thousand years of human evolution. You

can reach the heights of your imagination because you've avoided falling rocks and cold weather and dinosaurs and the continents pulling apart and floating out across the earth. You can finish that difficult assignment because you invented fire. Not to be hyperbolic but if we can figure out how to fly three hundred people around the world while offering a selection of recently released movies for their entertainment, you can reply to that intimidating email or whatever your thing is today.

There's so much we've chosen to no longer internalize on a day-to-day basis. We breathe constantly, so it stops being incredible. We move from place to place, so now it's just "that thing" our body can do. To a degree we are choosing to ignore miracles just to save time, which I think is okay in order to exist without stopping to marvel at the endless possibility of The Universe every few seconds. So why are we instead internalizing fear around things we can't do? Why are we clearing out necessary mental space and then filling it with negative self-esteem and a nagging voice that doesn't believe in us despite all the evidence and near-constant proof that we are living miracles?

It's not quite so simple. You can't 100 percent just "stop doubting yourself" or we'd all stop doubting ourselves. I'd love to stop doubting myself! It would honestly be such a great help, and I would get a lot more done and also have more fun doing it. I am still human and susceptible to all the less-miraculous but innately human things like self-doubt, fear, and anxiety. It's hard to stop all that negative self-talk at will. But one thing that's easy, or at least easier, is to do more of literally everything else. Am I still nervous about things I might not be able to do? Yes. Can I take a moment to remember that my own magical skeleton defies gravity every time it gets out of bed? Also yes.

We do great and special things every single day without thinking twice about it. So what if we all just thought about it a little more? What if we considered the things we take for granted, inspected the pieces that we've stopped counting, and analyzed some of those parts of being alive on this planet that make us feel a little spirally sometimes? Against all odds, you are here. You do amazing things every day. Whatever the next challenge is, you can do it. Whatever it is. Probably.

MOST OF US HAVE
ROOTED OUR SENSE
OF SELF IN A RANGE
OF IDENTITIES THAT
AREN'T NECESSARILY
MORE THAN JOB
DESCRIPTIONS OR
HOBBIES

WE MAY HAVE
INTERNALIZED
VALUE SYSTEMS
THAT ENCOURAGE US
TO DEFINE OURSELVES
BY THE SKILL WE USE
TO GENERATE INCOME...

LET'S STRIP THAT
AWAY FOR NOW

WE MAY HAVE PEGGED
A LARGE PART OF OUR
IDENTITY TO OUR
PHYSICAL APPEARANCE,
WHETHER GENETIC
CHARACTERISTICS OR
THE WAYS WE PRESENT
OURSELVES TO
OTHERS

THERE IS A LOT TO BE
SAID FOR COMMUNITY
AND THE PEOPLE WE
MAY HAVE RELYING
ON US OR CHEERING
FOR US ON THE
SIDELINES

PEOPLE WHO LOVE US
CAN HELP US DEFINE
OURSELVES, BUT
ULTIMATELY IT WILL
ALWAYS BE UP TO YOU

WHO ARE YOU WHEN
YOU CONTINUE TO
PEEL BACK THE LAYERS
OF WHAT, WHERE,
AND HOW?

WHAT IS LEFT AS
YOU REMOVE LABELS
APPLIED (BY YOURSELF
OR OTHERS) THAT YOU
HAVE INTERNALIZED?

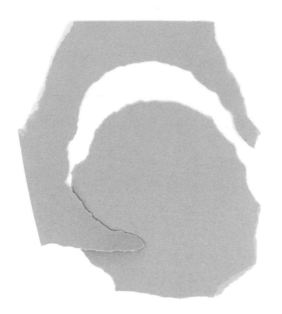

THE PERSON INSIDE YOUR
MIND WHO IS READING
THESE WORDS, CONSTANTLY
NARRATING YOUR
EXPERIENCE, CYCLING
THROUGH MEMORIES AND
CRINGING AT A DUMB
THING YOU SAID FIVE
YEARS AGO? THAT'S
THE PERSON YOU HAVE
TO LIVE WITH FOR THE
REST OF YOUR LIFE

DON'T LET THE BEAUTIFUL
NONSENSE OF BEING
ALIVE PREVENT YOU FROM
BEING IN HONEST
CONVERSATION WITH YOURSELF

IT'S TEMPTING TO
KEEP ANXIETY AROUND
WHEN IT FEELS LIKE
PRODUCTIVITY...

BUT THERE'S HONESTLY
NO POINT

NEVER FORGET THAT 1 THING

Part of being alive is getting caught up in the day-to-day bullsh*t that comes with being a person in the world. Life is really just a series of tasks and challenges and moments for all of us, and that can be absolutely beautiful sometimes, and incredibly difficult other times. There are moments that shock us into remembering our mortality, there are challenges that force us to face our deepest insecurities, and there are tasks that feel outside the realm of our possibility, asking us to stretch beyond our known resources to come up with something new. It's not our job to compare our experience to anyone but ourselves, but even if you know objectively that your own set of current challenges pales in comparison to the previous challenges you've overcome, they're still happening right now, and you still need to get through. One thing that helps drive us forward is Purpose.

There are different ways to arrive at Purpose, and ultimately, a lot of life is about identifying yours.

Purpose isn't necessarily a single thing, it's not the same for everyone, and it's not always permanent. Your Purpose might change. Your Purpose might be something that was instilled in or assigned to you at some point, and over the years it may fade away until you don't know if you feel it anymore. This can happen. This is okay. This is part of the journey as the reality of life continues to transform you from who you were into who you'll be next.

Many of us don't know exactly what our Purpose is. You might have a good *idea* of what it is, often referred to as a "Sense of Purpose," which can be plenty to work with for a long while. A guiding concept or series of principles that inform how we act, what we do, and the ways we care for ourselves and others. Congratulations, you are on your way.

Others are further from identifying a Purpose and are still searching. Good news here too, because Searching for Purpose is in and of itself a Sense of Purpose! It's kind of a cheat code for the whole thing, except that there's no cheating because you're already the only judge and jury involved. If you're Searching for Your Purpose, we can work with that. If you say you're Searching for Your Purpose but internally

understand that you were once but have since lost the plot, maybe it's time to regroup. As the sole decision maker in your own personal sense of direction and contentment, you have the power to intervene at any time, or the ability to let yourself slide for as long as you choose.

There's not a wrong way to be alive. You don't *need* to have a Purpose to be alive. You don't need to find your truth and hold onto it. I just think it helps! It's a little bit like faith, but it's rooted inside you instead of . . . you know . . . everywhere and nowhere else. A Sense of Purpose is a core truth that helps guide you through the hard parts. When things get dark and you're not sure where to go or how to be, having something that feels integral to your identity as a person can guide you through. While not necessarily a happy thought, it can be a valuable morale boost that reminds you why you're "here" (in this immediate space, in your community, or alive on this planet).

The dark parts will come. The daily bullsh*t can pile up rapidly, pressing in on itself to become weeks, months, and even years that feel like an exercise in keeping plates spinning, or putting fires out, from

morning to night and then starting all over again. A mood bubbles up into a perceived reality that takes over for a while. You stop swimming and start floating, which is still not drowning, except you're not really going anywhere unless the current carries you, and it's a slow process. "Not drowning" is, to be totally clear, still an accomplishment. Keeping your head above the water when all you want to do is sink is hard work that deserves recognition. But it's not sustainable long-term. It's exhausting to float alone. Your Purpose can serve as a life jacket, or a giant, inflatable, heart-shaped pool float.

I'm not especially religious, so for me, a Sense of Purpose isn't tied to worship. For many people it is, and that can be great and helpful to them. Religion folds in other important pieces of the whole "being alive" experience, like ritual, community, and, if you're lucky, music and special foods. But even within religion there's still the individual Search for Purpose, the same unique and human challenge that everyone faces, despite a foundation that may come with a one-size-fits-many structure for how to live.

As you grow and learn more about yourself, the world, and your place in it, your Purpose may reveal

itself. You'll identify more of your personal strengths and weaknesses, the talents you possess innately, and skills you've honed. Your unique blend can mesh with the people around you in a symbiotic way that keeps everyone going, which to me, feels like the ideal way to live because my Sense of Purpose is rooted in ideas of service. Unfortunately (or fortunately, I think!!!), you can't choose a predefined Sense of Purpose from a book. You can find one from clues placed or created, but once again, you're the only one who can really decide.

You will change. The challenges will change. Life will change, and I will change, and everything will change over and over again, rooted in a common place or self but shifting along with everything else. This is being alive. This is the process. Your truth will remain one constant through it all, leading you along while tethering you back to the core of who you were, are, and will be.

I go through phases of understanding what my Purpose is, and at times it may be buried in distraction, or in a natural process of revision. But holding onto at least my Sense of Purpose helps me keep going. It guides me when I forget what's

happening, or things get too dark, or I don't know what I'm doing with my life, or I've felt stagnant for a bit too long. While it's internal and just for me, I wrote an external reminder, "NEVER FORGET THAT 1 THING," on a notepad, then a sticker, and then I got it tattooed on my arm, so I don't forget to remember.

You can't pick a Sense of Purpose from a book, but here are a few ideas to think about for anyone searching: being a good person is never a bad idea, loving yourself is not the same as vanity, and being genuinely kind is not a sign of weakness.

BEING A GOOD
PERSON IS NEVER
A BAD IDEA

LOVING YOURSELF
IS NOT THE SAME
THING AS VANITY

BEING GENUINELY
KIND IS NOT A
SIGN OF WEAKNESS

STEP ONE:
ACKNOWLEDGE THAT
LIFE IS A SERIES
OF STEPS

STEP TWO:
KEEP CLIMBING
FOREVER

YOU WERE BORN
AND NOW IT'S TOO
LATE TO TURN
AROUND, SO YOU
MIGHT AS WELL
EMBRACE IT

WHILE THERE IS
NO "BACK," THERE
ARE MANY, MANY
WAYS FORWARD

BELIEVE IN
YOURSELF THE
WAY YOU BELIEVE
IN THE PEOPLE
THAT YOU LOVE

THE DISTRACTIONS
ARE A WONDERFUL
AND SPECIAL PART
OF BEING ALIVE

(BUT KEEP GOING)

CREATING CHANGE
IS A CHOICE AND
IT'S USUALLY NOT
THE EASY ONE

EVERYTHING YOU'VE
ALREADY ACCOMPLISHED
IS A MOUNTAIN THAT
SOMEONE ELSE IS
TRYING TO CLIMB...

MAYBE YOU CAN GIVE
THEM A LEG UP!

SOON

NOW

THEN

BAD NEWS PEARS

Sometimes I get too caught up in my phone and all the terrible things happening in the world. I open the phone and yes, sure, I feel connected to my friends and the specific blend of opinions I've invited into my feed, but there is an overwhelming amount of news that is hard to digest and a pervasive, low-level feeling of panic and dread. I have felt this regularly for a few years and have taken some steps to mitigate, such as turning off all news media push notifications on my phone and occasionally muting the sources of information that I need a break from.

The reality is not that bad things have suddenly started happening with alarming frequency (although in some ways, the results of our actions as a whole, such as ignoring climate science, have absolutely brought us here). The truth is that humans have long been completely terrible to each other, corporations have put profits over people, and some of us have been turning a blind eye to the suffering of others. Whether this is a conversation we're all having or not, these things are occurring. And now we're seeing more of it.

Technology has made capturing and distributing information incredibly easy, and so we are witnessing, sometimes in real time, crimes against humanity. We are witnessing, sometimes as it happens, people dying, suffering, or causing harm to others. There is so much of it, and it's all around us, and it can be overwhelming, and so at a certain point the impulse is to just log off. The impulse is to disconnect and shut down.

What's most healthy for you right now and most healthy for all of us in the long term may not be the same thing. It's my feeling that taking some time away from the endless news cycle is helpful and sometimes necessary, especially if you are in close proximity to the subject. Basically, if you're feeling particularly overwhelmed, opt out. Take the time you need and once you feel safe again, come back in. For most of us, the endless cycle of "sadness, outrage, desire to take action, manageable action, keep moving" is unsustainable. The pent-up rage, tight shoulders, and clenched jaw help nobody and take years off your own life. There has to be a balance.

One thing to remember is that good people are out there. Good things are happening. While outrage

tends to spread faster, good news exists too. In fact, it's often not newsworthy at all, because by definition, the commonplace activity that is ever present around us isn't news. There is overwhelmingly so much goodness in the everyday experience of being alive, so many positive interactions and occurrences in our communities, that it is simply not reported to the same degree. So we focus on the things that need changing, or the sensational headlines that blend fact with emotion for the sake of shock-entertainment, and forget that everyday people are doing everyday things.

Every single day, someone is saying something positive to someone else out of kindness or gratitude. Every single day, someone is doing one small action that betters another person's life, even if they don't know it. Every single day, people are preparing meals for the ones they love. Every single day, people are going to work, even if they'd rather not, to care for, impact, or better other people's lives. Every single day, you are doing some good, even if you don't think about it that way.

Opting out of the constant stream of negative for a bit doesn't mean pretending it isn't happening. Your bubble might feel safe for a while but it will

always, always burst. Bubbles are beautiful iridescent floaty magic but incredibly thin and literally empty. The bubble is not sustainable. It is a wonderful place to visit, to feel temporarily childlike (assuming you had a pleasant childhood) but there is an expiration date. If you need a reprieve, allow it, but keep one eye open to the reality on the other side of your rainbow perimeter because even a bubble has to exist in space, and space is complicated.

The most sustainable solution I can think of is one where "good vibes" and "bad vibes" and midrange "OK vibes" coexist. It is only when all our vibes can vibe together that we can ever truly reach vibe equilibrium, not a temporary bubble but a novelty mold of fruit and cream and hope and fear suspended in red Jell-O forever. This unfortunate dessert is the closest thing to reality as we know it, a mixed bag of good and bad that has to be acknowledged equally because a little bit of everything is happening at all times. You can pick around and eat your favorite fruits first, but eventually you'll be left with nothing but a soggy pile of canned pear slices and you'll have to eat those too.

HAPPINESS IS (KIND OF) A CHOICE

Some people are happier than others. Just by nature. This is one of those we're-all-different things, and some of us are happier and that is lovely and I am . . . happy . . . for those people. But I'm not really one of them, and maybe you aren't either.

Smiling is free! A smile can brighten someone's entire day! But sometimes it's too hard. Sometimes it's not even that hard but I just don't feel like it. Happiness is a choice, and if I'm being honest it's not a choice I choose all the time, even if I'd obviously feel better for it.

I've heard that if you're not feeling great you should fake a smile and eventually it'll become real. I think about that sometimes. Do you ever just look at yourself in the mirror for a little longer than normal, make some faces, and then do scary eyes and actually slightly freak yourself out? But then you smile and laugh? Historically, that has worked for me before. Sometimes, the real smile emerges.

We've learned from fortune cookies and tea bags that happiness is not a destination but a journey. Happiness is a constant ebb and flow that requires work. Sometimes you're happy for no reason, which to me is the best kind of happy. Sometimes it's the result of someone else's impact, so let's take a moment to thank and acknowledge these happier people for extending a little joy our way. Often it's the result of an occasion, something nice we've done for ourselves like a cup of coffee or ten minutes alone or listening to our favorite song while power walking down a very long hallway when we think nobody is around. These are choices we make to treat ourselves to a moment. This happiness wasn't there, and then we created it. This happiness was a choice.

There are many situations when it would be much easier to feel anything other than happy. In light of a scary, difficult, or tragic experience, it's often simplest to let yourself feel afraid, stressed, or sad. In fact, those are totally normal and natural responses worth feeling and sitting with for a while, before working to explore and address their root causes. Processing our emotions fully helps us

understand why we might feel the compulsion to do the things we do and help us fight back against those impulses when they're not good for us. If every time I'm stressed I do something that is objectively less than positive to soothe myself, I might want to start addressing the stress instead of going straight to the coping mechanism.

Happiness is a choice, but that doesn't make it easy. This is not "CHEER THE F*CK UP" (although I think that is also funny in the right context). This is "make the choice" to "do the work" to "create happiness." This is getting really, really real with yourself and deciding, maybe after a long time, that happiness is something you're struggling with. This is choosing to bridge the gap between where you are now and where happiness can be found. This might mean making real life changes that create an environment of happiness for yourself.

Choosing happiness means choosing yourself over the situations that lead to (or even benefit from) your unhappiness. You may have someone in your life who does not seem to prioritize you the way you prioritize them. You may feel stuck in an environment

that doesn't give you the time or space, or leave you with the energy it takes, to be happy. Sometimes choosing happiness means extracting yourself entirely. Other times it's less drastic, but still requires some work to rethink how we allow external circumstances to impact our interior selves.

How can you filter out some of the sh*t? How can you find the silver lining that makes this period of intense, hard work worthwhile? Are you struggling now because you're on the path to where you want to be? Or are you struggling now because of a circumstance that makes everyday survival a struggle?

I don't have answers here, because the circumstances are different for all of us. I just have questions that you might want to seriously consider. Step outside your reality and really ask:

Is this necessary? Am I preventing myself from happiness that I genuinely deserve? Does this person care about me the way I deserve to be cared for? Does this situation lead the way to a better life, or am I blindly going through the motions?

Just because it's a choice doesn't make it easy. Keep asking the questions:

Am I placing my happiness entirely in external circumstances? Am I seeking happiness in material things or experiences or attention from others? Am I unable to source it from within at all? Am I allowing myself to sit in negative emotions for longer than is helpful? Am I avoiding the hard work?

Your mental health is real, and like everything else, could benefit from a professional checkup now and then. I'm not here to diagnose anyone (nor am I a licensed therapist), but it is extremely normal to need a little help. If you were bleeding, I would suggest a bandage. If you're peripherally aware that you have a hard time feeling okay, even when the circumstances seem stacked up toward happiness, choose to embrace the reality that you might be having a harder time dealing with it alone than is necessary, and look for resources that might help.

Being aware of your mental health choices gives you extra options. Understanding that what you're feeling might not be rational gives you the opportunity to review your past attempts at dealing with the same feeling and get straight to the root cause this time.

Do I need to go for a walk? Do I need to get more sunlight? Do I need more nutrients? Do I need to get my heart rate up? Do I need to listen to Whitney Houston's "I Wanna Dance with Somebody (Who Loves Me)" until everything is okay again?

You might think you know what your options are, and maybe you've already made the choice that seemed best. But what if there were more options? (There are always more options).

What if the happiness was inside you all along and just needed a little help being amplified?

Yes, turn that frown upside down. But also, talk to your doctor about the tools and resources you can have access to. A carpenter doesn't build without tools. Using a hammer isn't a sign of weakness, it's literally how to get the nail into the wood to hold the frame together. If happiness isn't sinking in, trying to smash it in with your bare hands is not only useless, it might hurt. Familiarize yourself with the full toolkit, or at least learn enough to know which tools you already have and which you might turn to later as a backup plan. If necessary, you can hit a nail with a brick. It's just a lot more complicated than using a hammer, and it doesn't have that claw to pull the nail back out.

Choosing happiness isn't as easy as it sounds. But you only get one life, and the sooner you make positive changes, the more time you'll have to explore what it can feel like.

YOU ARE NOT DEFINED TODAY BY THE FEELINGS THAT YOU FELT YESTERDAY

I THINK WE ALL
UNDERSTAND THAT
CHANGE REQUIRES
CHANGE

HAPPINESS (AND
ALL THE OTHER
THINGS WE MIGHT
WANT) WILL TAKE
SOME WORK

DREAMS DO COME
TRUE, BUT IT MAY
NOT BE THE SAME
DREAM YOU THOUGHT
YOU WERE LOOKING
FOR

BEND A LITTLE AND
YOU'LL FIND THAT
THE WORLD MIGHT
MEET YOU HALFWAY

FAITH IS COMPLICATED
BUT BELIEVING IN
SOMETHING INTANGIBLE
CAN MAKE YOUR LIFE
EASIER TO NAVIGATE

FOR YOUR CONSIDERATION:
BELIEVE IN LOVE

LOVE IS POSSIBLE

LOVE IS OUT THERE

LOVE IS REAL

LOVE
ITSELF
IS PROOF
THAT
LOVE
EXISTS

IF YOU ARE PATIENT
YOU MAY JUST FIND
THAT LOVE WAS
INSIDE OF YOU
ALL ALONG

LOVE IS REAL

As an idea, love is so pervasive that it permeates every element of our lives. "I love you" ends conversations, "I love it!" communicates appreciation, and of course everything can be "just lovely" even (or especially) when it's not. We understand love as a concept, shorthand for a feeling of connection, but we don't always "get" it. Or at least I didn't.

Sure, I love my family, I love my friends, I love bread, I love music, but like, what does that actually even mean? The Monkees sang "I thought love was only true in fairy tales," an idea amplified for later generations by Smash Mouth's cover version for the *Shrek* soundtrack. For a long time I had to agree, love was something that was out there but "meant for someone else but not for me." It was broad and abstract and so apparently meaningful that it became completely meaningless.

"And then I saw her face!" Well, not exactly, but close. I saw a photo of a cute guy and followed him on social media for six months before finally asking him out at what turned out to be exactly the right time for us both.

I fell in love and it was so real, and so possible, and happened so fast and so hard. Love! A real human emotion, a feeling composed of so many other feelings (excitement, anxiety, desire, terror) that steered my decision-making, consumed my thought process, and defined so much of those early days of our relationship.

Many people already understand love in a tangible sense, not necessarily needing to wait for grand, romantic gestures and candlelight to recognize it as true. Unfortunately, I was just a little late to the whole thing—part ignorant, part jaded, part blind. Understanding love beyond pop songs and greeting cards snapped into place a range of other emotional realities for me. The genuine bonds we can create with others, tethering two people who otherwise have no shared history. Two people with nothing to necessitate a bond. And yet here I am, enjoying the lovely love things while also mentally deciding how and when I would take a bullet for this person who was once a total stranger if necessary. I just love love!

Love has encouraged my personal growth, love has led me to greater understanding of

others, love has given me something to hold onto when I was tired of holding on, love has helped me create new potential futures to work for and toward. Love is real and so are myriad tangential emotions. Love is real so feelings must be valid. Love is real and everyone has the capacity for love. Love is powerful and so everyone must have the capacity to hold power. "Love is love" (but actually).

Love wasn't real to me because I hadn't felt it in the most obvious, dramatic, romantic sense before, causing me to overlook the many forms of love I had already experienced. Many people have believed in love once, then forgotten or changed their mind. Belief in general can be hard to reconcile with, especially for those of us who have been disappointed by other forms of faith. You may have felt a version of love before, and had your heart broken by the rush of everything and the eventual dissolution of that relationship. But love itself is proof that love exists. If you've felt love for someone, then you know it's a real thing that people can feel. If love is real then there's definitely hope that you'll feel it again.

Ultimately, words are just words on this one. You need to feel it in the most deep and innate sense to know it and live it and hold it. If you're still waiting to know, I hope you'll choose to believe. For me, this knowledge has led to belief in the true power of love to bridge gaps and drive change. I've fashioned this faith into a mantra that keeps me tethered when I start to lose it. Take it if it helps and make it true. GOOD THINGS HAPPEN. LOVE IS REAL. WE WILL BE OKAY.

GOOD THINGS
HAPPEN

LOVE IS REAL

WE WILL
BE OKAY

NEGATIVITY
PROVIDES CONTEXT
FOR POSITIVITY

*UNFORTUNATELY
WE NEED BOTH

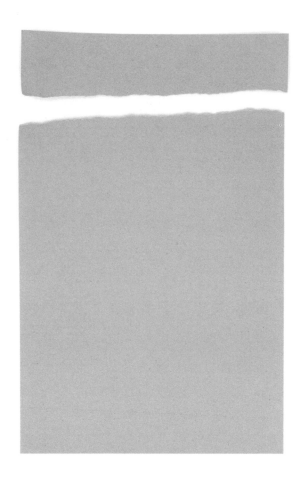

YOU ALREADY KNOW
HOW BAD IT CAN
BE, SO FOCUSING
ON POSITIVE CHANGE
INSTEAD ISN'T THE
SAME THING AS
IGNORANCE

YOU MAY BE
ALONE ON THIS
JOURNEY BUT
THAT DOESN'T
MEAN YOU CAN'T
SEEK OUT SOME

ASSISTANCE

THE WORLD IS JUST
SO MUCH BIGGER
THAN WE CAN
REALLY FATHOM...

WHY WOULDN'T
THERE BE SOMEONE
ELSE WHO
UNDERSTANDS?

USE THE TOOLS
YOU HAVE, OR
FIND THE ONES
YOU NEED

MAYBE YOU
NEEDED TO BREAK
APART TO TAKE
UP THE SPACE
THAT YOU
DESERVE?

BREATHE IN

BREATHE OUT

BREATHE IN

BREATHE OUT

REPEAT FOREVER

I AM A TOOL OR A WEAPON AND COMPLETELY FREE WHICH IS LITERALLY TERRIFYING

I am extremely obsessed with pencils as a metaphor. Pencils are one of the most ubiquitous tools I can think of, an everyday utility item for writing and other forms of creativity. They're affordable, long-lasting, and since 1858 even include erasers on one end (genius). You probably have a pencil within twenty feet of you right now. Pencils have played a core role in countless important creative works, and are all but indispensable in the process of sketching and planning nearly anything. Most of my work is pencil on paper. Pencils have given me so much.

You can also murder someone with a pencil. With enough force and focus, you can stab through the back and puncture a lung (I have not tried it). A pencil is both an incredible tool for creation and a literal weapon for ending a life . . . and so are you.

Everybody is special and unique, and you are special and unique, but let's face it, there are a lot of us. Like pencils, human beings are pretty common. You probably have a human being within twenty feet of you right now! Each of us contains a world of possibilities, to do good, to make change, to create meaning, to make a sandwich. We also contain within us the capacity to harm others, to harm ourselves, to destroy a life or an opportunity or a home. You are a tool or a weapon and possess free will. Yikes.

For me, I had a very dramatic "aha!" moment around twenty-three years old in which this idea became clear to me. I was someone who didn't entirely believe in themselves, and then suddenly I did. It all clicked, and I understood that I had potential, that I could make something good and share it with others, that I could have a positive impact, and (to oversimplify but bear with me) the only thing stopping me was myself. All I had to do was try, and I could create something. Or anything!

This feeling rocked me to my very core, because it was in conflict with so many lies I had

told myself about my ability, my value, and my worth. I felt infinite potential as an artist and as a person. Suddenly, I had something special—me—and suddenly, I had something to lose. It felt like I had unlocked a secret and the universe had opened up somehow and I gained a magical power. In some ways, self-confidence for someone who lacks it *is* a magical power. I was so thrilled and also suddenly so scared as I realized that my power could be both good and bad, and also, I could die before ever using it for anything.

Obviously, none of this was rational, and it was absolutely a product of many other circumstances and stressors in my life that caused me to maybe forget that I had power, and to lose sight of my reality in the first place. I was probably not in immediate danger of dying. But to make sure I didn't forget, I did the thing I often do, which is to write the idea down. Also very like me, I wrote it down on an object, turning yet another piece of advice into my version of a pop song: a novelty stationery product. I went to the internet and ordered seven hundred and twenty printed pencils.

I AM A TOOL OR A WEAPON AND COMPLETELY FREE, WHICH IS LITERALLY TERRIFYING. Five gross (that's 5 x 144) reminders of my own potential and mortality, printed on the barrels of classic, yellow, hexagonal, No. 2 pencils.

In the years since, I have come back to this phrase over and over again. Any time I lose my nerve, any time I forget my innate power, I remember. I am a tool or a weapon. Having power is scary. Every day is a choice. It is scary to make that choice. But making that choice is core to being a human being. I am a human being. Pencils are a tool. I am a tool. That is funny and also true. I am funny and true. I deserve to exist. I can make things that didn't exist before exist now. This is a gift. I am a gift. Repeat.

Each of us contains an innate power to create or destroy, and every single day we get to choose what to do with this power. Some days we will use our power to lie down on the couch and watch TV and eat popcorn. Other days we will spend twelve hours hunched over a desk creating something terrible, which with a long journey of editing and patience, can become something special.

Someone will write the next great novel that will define a generation. The novel inspires a group of musicians to craft a massive rock anthem that motivates a top athlete, who encourages the next generation of athletes to break down barriers and change the game forever. Our ability to create change may extend far beyond our individual reach or lifetime. Some of us will also destroy, hurting people around us with words or actions, or hurting ourselves through unfortunate personal choices.

To me, the pencil is important as a great equalizer. We don't all have access to the exact same tools and resources. We don't all have the same supplies. We don't all come from the same privilege, with the same encouragement or inspiration. But most of us have access to a pencil and paper. Most of us have access to this simple tool, and the capacity to use it to create something new. That thing might not be great. That thing might not be important. But if we can use what we have on hand to make something that brings us a moment of joy, or one step closer to the next thing we might do, then we've used our power for good.

As I continue to grow as a person and an artist (a person with a voice who has learned to wield it into something that can help themselves and others) I have learned new tools. I have embraced technology and software that aids in my ability to create. But I have never forgotten the pencil. Even as the option to digitally recreate its effect has become more and more convincing, I have held steadfast to the belief that there is something so intrinsically human and innately emotive about a pencil that I continue to use it. Not just for myself, but as a core element of my work, integral to the very ethos of what I create, how I create it, and my mantra of THINGS ARE WHAT YOU MAKE OF THEM.

Ultimately, all of us have power. Ultimately, all of us have access to enough resources to make something of our tools, of our experiences, and of ourselves. You are completely free, and while that is scary, it is also incredible. I didn't believe in myself, but I do now, and I believe in you too.

THINGS
ARE WHAT
YOU MAKE
OF THEM

MY COPING MECHANISMS ARE MY TRIGGERS BUT HERE THEY ARE ANYWAY

Self-care is genuinely so important, and it's been amazing to witness a culture of, and appreciation for, self-care practices, techniques, and rituals that has grown stronger over the last decade. Maybe it's the space I navigate, maybe it's culture at large, but I find it genuinely so helpful that I can talk about the things I need for myself in order to feel sane and have people know where I'm coming from and not judge me for being needy or selfish. It feels like mental health is being widely recognized as . . . real . . . and accommodated for in at least some ways.

A cool thing about me is that I am constantly analyzing everything. Maybe not all at once (thankfully), but I'm definitely overthinking and deconstructing things that I would be better off just navigating or enjoying. It's not that I'm highly intelligent, it's that my brain *thinks* I'm highly intelligent and it seems hell-bent on convincing me of just how smart I am by having me constantly

process things I don't need to process until I ruin every experience for myself.

And so, like someone screaming "CALM DOWN!" when you're stressed out (not that helpful), my brain identifies that I'm losing my sh*t and immediately feeds me a list of self-care tips to combat the feeling. Drink water. Yoga breaths. But then, in my brain's infinite faux-wisdom, it identifies that these are coping mechanisms, which therefore means there is something that needs coping with, triggering a secondary red alert because now we're not just worried about the root cause of this anxiety or panic, we're also on a general high alert for a Mental Illness Event which requires we double down on the whole thing.

The nice thing is that a lot of these tips that start to flood my brain are useful and actually help. As I understand innately thanks in part to Michelle Branch's hit 2003 single "Breathe," if I just breathe and let it fill the space between, I'll know everything is all right. My body might actually slow my heart rate down and I can stop the whole process before the red alerts and coping mechanisms really start to cycle out into full-blown mania.

Here is a list of useful coping mechanisms that you can transform into personal triggers or distractions from actually dealing with the root cause of your sh*t. Or if you're not me, they might just be helpful tips!

- Create space for yourself (physical distance from other things).

- Do some intentional deep breathing.

- Have a glass of water because you are water and you need water and everything is water.

- Create space for yourself (emotional concept of a safe "place" to "go" "to" in your mind).

- Portion out a small number of baby carrots and then feel their nice cold crunch.

- Give yourself time because it is not a race (even if you are sweating for some reason).

- Contemplate what it all means (in a non-spirally way).

- Be patient with yourself.

• Smile at yourself in the mirror until you feel like smiling for real (because the smile trick worked or because it's genuinely funny to smile at yourself in a mirror for more than five seconds).

• Listen to that song that's hardwired into your body that you know every word and note and beat and breath to, that puts your entire brain into autopilot mode.

• Do something with your hands (clench fists, hold your own thumb, hold your hands behind your back, wiggle fingers).

• Do something with your hands (something tactile like rake a Zen garden just kidding who has an emergency Zen garden on them at all times but maybe you could fold and tear and roll up scraps of paper over and over into tiny little paper straws or tight accordions or a pile of confetti until you lose it in your pocket or save it in your wallet for three years or make it into art for this book).

• Make mouth sounds (loud vowel sounds or singing or talking to yourself, as long as nobody is around to question your sanity).

- Go for a walk.

- *Don't* drink a coffee (massively underrated but highly recommended).

- Watch a movie alone (sit in a dark room where it's definitely okay to cry).

- Read a book so your brain has to focus on something that's not you.

- Call someone (only if you're either ready to speak calmly to another person or you're so far gone that maybe you need to tell someone so they can help).

- Look at inspirational therapy memes and then share a few too many in the group chat until someone asks if you're okay.

- Talk to a therapist (it's literally their job to listen).

- Take your medication as part of a holistic and collaborative approach with your doctor.

- Write a list of self-care tips.

MAYBE LET'S
TALK ABOUT

THE THINGS WE
DON'T TALK ABOUT

BEFORE IT'S TOO
LATE TO TALK
ABOUT THEM

EVERYONE
STARTED
SOMEWHERE

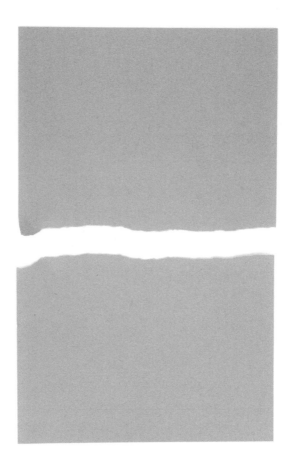

IT'S OKAY AND
TOTALLY NORMAL
TO FALL APART
SOMETIMES...

TRY TO HOLD
ON TO THE
PIECES

IF AT ANY POINT
YOU FEEL LIKE YOU
DON'T HAVE ENOUGH
TO MAKE SOMETHING
WORTH ANYTHING,
REMEMBER THIS IS
LITERALLY JUST
PAPER AND PENCIL
AND IT'S STILL
ALLOWED TO
EXIST

TIME DOES IN
FACT HEAL MANY
WOUNDS SO YOU'LL
JUST HAVE TO
WAIT AND SEE!

I USED TO THINK
YOU COULDN'T HAVE
TOO MUCH OF A
GOOD THING...

I WAS WRONG

WHAT HAPPENS
WHEN YOU GET
WHAT YOU WANT
AND THEN YOU
WANT SOMETHING
ELSE?

SOMETIMES I FEEL
TOO SMART FOR
MY OWN GOOD

OTHER TIMES
I DON'T FEEL
ANYTHING

STAY CALM

BREATHE DEEP

DRINK WATER

IT'S OKAY

KEEP GOING

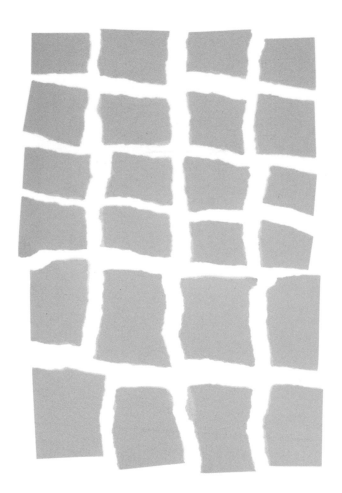

IT'S OKAY TO
NOT ~~BE OKAY~~
FIND YOURSELF
COMPLETELY
HEALED BY A
CATCHPHRASE

(ASK FOR HELP)

SURE, DEATH
IS INEVITABLE,
BUT IT REQUIRES
NO IMMEDIATE
ASSISTANCE

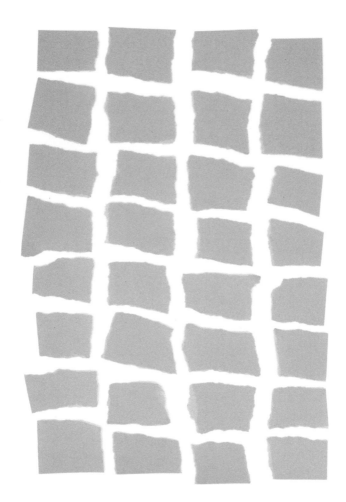

YOU DESERVE
TO BE HERE
AS MUCH AS
ANYONE ELSE

SOME PEOPLE THINK ABOUT DYING SOMETIMES 😊

I know what you're thinking. This is a cute little book of "self-care vibes" and it's "cheaper than therapy LOL," but let me just clarify that being happy or optimistic is a choice (that I don't always choose). It is sometimes difficult just to be alive.

Being alive doesn't actually require constant cheery optimism, and we all have bad days. It's important to acknowledge these less-than-happy emotions so we can inspect, work through, and move on from them. But sometimes it's more than a bad day, and sometimes it's hard to move on.

Talking about death feels very normal to me. It might be a cultural thing. Growing up in a Jewish home we often discussed family members who were not with us anymore. There was a whole wall of framed photos of relatives whose lives were cut short, and I think a dark sense of humor became a coping mechanism for myself and many others. You might be able to relate for your own reasons. Plenty of cultures embrace death as a part of life,

and dark humor isn't strictly for Jews (though sometimes I feel like we've perfected it). I don't necessarily feel as spooked by conversations about death or even the occasional joke as some others might. I mean, even the expression "just kill me" is a softer version of this idea that we as a society have seemingly okayed for conversational use without any necessary addendums. "You forgot to buy the ice cream I wanted? *Ugh, just kill me!*" Dramatic, but socially acceptable.

Talking about actually wanting to end your own life? That's kind of a different thing.

First of all, yes, please talk to someone if you feel this way because the feeling will pass and it's nice to have some company and help while you wait. That's as prescriptive as I'm going to get here, but you know what I'm talking about and obviously I'm on Team Don't Kill Yourself (we should make T-shirts). When I really, deeply, genuinely, full-body felt like I did not want to exist anymore, I got help. But then I didn't really talk about it ever again until now.

I think it's important to acknowledge that there are many people who are alive in the world who have at one point or another thought about

dying. If you can relate, know you are not alone. If you can't relate, I am genuinely happy for you! Sounds amazing.

Gratefully, I haven't felt quite so low again since, despite dips of despair and apathy over the years. Healing is an ongoing process, and so I am always healing. But I remember what my lowest point felt like and it has informed a very specific kind of empathy that I have carried with me since.

I, not just in theory, know what it's like to be there when it feels like you are out of options. I also know how a support system of relationships, therapy, medication, care, and self-awareness can keep a person from dipping that low again if they're willing to work at it.

Should we all shout our darkness from the rooftops? Should we actually wear it on T-shirts? The answers are no (stay off the roof) and maybe (if they're cute).

Compartmentalizing what we share with others is how we protect ourselves! There's also no easy way to bring this up in casual conversation. So I am doing this here and now, in my own safe book space, with a level of vagueness, layered in my own

versions of humor and sensitivity, in my own voice, as pure as I can get it: I genuinely wanted to die but then I didn't die! With work and time and help I got better and felt better! Things aren't perfect but they are pretty okay! I can write this entire paragraph without freaking out!

Eventually you will feel better. Life will get better because you will survive and grow and accomplish and connect and find power in who you are. Things that are hard today will be easier if encountered again. You will learn so much about yourself. There is so much to come, and it would be great if you were still here to experience it all.

REASONS TO STAY ALIVE

Let's just say hypothetically that there could conceivably be a scenario, in theory, where a person that neither of us knows, a friend of a friend, might feel like they do not want to be alive necessarily. Which of course is nobody that we know, so it's a very safe thing that we can talk about. Now that we have established the ground rules here, I have some thoughts on why it's worth staying alive:

• There's a lot left to do (including that one thing you keep putting off forever).

• Some people need you and they deserve having you around.

• It's okay to not be perfect and nobody expects you to actually be perfect so why are you holding yourself to this impossible and also unnecessary standard? Now that we have established this, you are fully good enough to be here.

• Your body regenerates cells all the time and so you will literally be another person in the future, and it would be awesome if you were here for that.

- There is so much music to listen to in the world and it has never been more available or accessible to you.

- We still don't know what happens at the end of Season 9 of your life, and a lot of fans are going to be mad if the series ends in a cliff-hanger.

- Science is real and there is plenty of science that tells us you don't actually need to feel so sh*tty all of the f*cking time so if that sounds familiar, now could be a good time to try some of it out and then we can circle back in like six months and reassess.

- Books, period.

- Have you tasted food? Some food is so good and so delicious and they just let you eat it, you can celebrate a special occasion (such as being alive) by eating a meal that is nutritious and flavorful and so, so satisfying.

- Death actually seems kinda painful, IDK!!!

- A lot of things in our life that are difficult or scary are entirely circumstantial, and so even if we personally are always going to be this version

of ourselves (which is unlikely), the events and situations around us definitely will not. You may actually be pretty close to who you're meant to be but dealing with an incredibly tense or difficult situation. That situation might resolve itself, or be resolved by you, sooner than you think. It's kind of a trap to define ourselves by the circumstances happening to us and not by the core of who we actually are. If you are reading this right now then at the very least you have the ability to read (a skill you acquired that you did not have at birth) and have carved out space for yourself to look at a book (a form of control over your own life and circumstance that you do have right now that not everybody always gets to have). You are not defined solely by the sum of your situation and you have more power than you think.

• Your experience can help others, and helping others can be an incredible and rewarding experience.

• Did I already say the music one because I love music a lot and I get so excited when musicians make new music and they are always doing that

because it's their whole deal. By the way, if you are a musician can I just say, wow, thank you. Music is so powerful and is to me undeniable proof that of course art is necessary and important.

• "The sun'll come out tomorrow," a quote from the musical *Annie*, is also objectively true. It's helpful to hold on to things that are objectively true when so much else of what you're holding onto is more or less fabricated by your brain and presented as truth.

• Staying alive is so easy that you're literally doing it right now so why even bother changing that up.

• Birds and fish exist! Birds are just out there in the skies doing their thing. Flying around in formation with other birds, looking at things, caring for their young, making a home out of random stuff they find, sitting on eggs for a while until they hatch even more birds. It's beautiful. And fish! Fish just swimming around in water, nibbling on crumbs, finding their place, gliding through the water with intention, or sometimes just super lazily, taking it all in with their big, round eyes. Have you ever

thought about how both "fish-eye" and "bird's-eye" view are a part of our human vernacular? We're so aware of their unique perspectives and the way they get to see and navigate space that we've incorporated how they perceive the world into our own language. I've never had a pet bird before, which seems like a lot of work, but I had a fish once. I would love to have a pet fish again and I could feed it the little fish food and get one of those small treasure chests to put in the tank. Anyway, don't kill yourself please.

YES THE SUN WILL
COME OUT TOMORROW
BUT IT IS ALSO OUT
LITERALLY RIGHT NOW
JUST MAYBE NOT HERE,
AND I PERSONALLY FIND
THAT VERY ENCOURAGING

WHAT COMES AFTER SURVIVAL?

One thing I know with absolute certainty is that everyone has been through some kind of hardship. A difficult, scary, or otherwise less-than-awesome experience or event that by not killing them, has (sung "in the style of Kelly Clarkson") made them stronger. While I wish this wasn't true, and that even if the rest of us have experienced this, you personally would be completely spared and instead get to have a 100 percent easy and okay life, I know that's just not how it works. If you're thinking critically about your life right now and have concluded, "hmm wow actually not me though???" then please, let me be the first to warn/welcome you, because some sh*t is coming.

The Thing, whatever it is, can feel like a lot of things.

First, it feels like The End. "This is it! Thanks everybody! I had a good run, made some friends, learned to ride a bike, ate a ton of different fruits . . . it was an okay life. But now everything is over because this Thing is actually crushing me, and I am literally going to die, and I'm being glib because it helps

me cope, but like yeah, goodbye, I'm so extremely scared and bracing for the end." It really does feel like The End, and not to be too dark, but for some people a similar experience actually could be The End, so in the most genuine sense, it is a miracle (or something) that you're still here.

Next, it feels like Your Identity. This monumental Thing that didn't kill you but seemed like it could is now going to define your entire life. I mean, how could it not? A massive, scary, all-encompassing Thing That Happened to you. "Oh me? Yes, hi, I'm The One Who Survived That Thing." This might feel like your identity because of others who can't seem to think of you as anything other than the experience. Every conversation feels like it's tinged with extra sympathy or caution and it's appreciated until it becomes annoying and unnecessary.

If it's not other people crafting this new identity for you, it might be you, struggling to figure out who you are after The Thing That Happened and defaulting to Thing-as-Self. Survivor's guilt keeps you tethered, and you find yourself unsure of who you are in the aftermath, even as time passes. Or the part of you that's been trained by

society and social media to commodify every lived experience into a bite-sized identity is now telling you to pivot your public-facing personal brand to #AmbassadorOfTheThing or some kind of #TheHappeningAdvocate. None of this needs to be true. The Thing alone is simply not an identity.

Eventually you keep going, as much because you want to as because you don't have a choice. Life only moves forward, and the only thing to do after a near-stop is to first catch up, then resume at a normal pace. But The Thing is there in the rearview. It's behind you, but you're keeping an eye on it, making sure it's staying back there, making sure you're putting enough distance between it and you to feel safe. You're in the driver's seat, but there's a small piece of you that's checking the rearview at all times, and that prevents you from ever looking fully forward, which in turn prevents you from feeling like you can really floor it. So you continue along, maybe just below the speed limit for a while, and then eventually keeping pace with everyone else. But every so often you have a tiny freak-out while merging lanes or rounding a sharp corner.

Finally, when people have put it out of their mind, and even you are keeping up with the world, there's still something there. The Thing becomes a marker of time and an invisible checkpoint between who you were before and who you are after. Your memories split into pre- and post-Thing boxes in your mind. With any luck you transform the experience into something that, while maybe still painful, can be a source of personal strength, proof that you are enough, and maybe adding an extra layer of empathy and understanding that helps you connect with others who have experienced similar or other hardships.

How do you figure out who you are in the aftermath of The Thing? How do you transition from Still Alive to Surviving to Normal Person? What steps do you take to let go of fear, feel secure in yourself, and move on full speed ahead? This process is going to be different for everyone. For me, it took a long time to see myself as more than any one dark experience. To understand that I am only defined by what I let define me, and to know that I deserve to keep moving, for as long as I'd like to, whenever I'm ready.

You may have experienced your Thing already. You may be experiencing The Thing right now. Some Things are global events, lived experiences that unite us, but also impact us differently. Whatever The Thing is or was, it's yours to identify, embrace, dissect, live with, and then move through. You'll never go back to normal. What is "normal" even? But while the process may not be as smooth as you'd like, healing through to the next thing that *feels* like normal will be possible.

You survived The Thing and that is a testament to your strength. You'll survive surviving it too.

WAKE UP
AND SMELL
THE ENDLESS
POSSIBILITY

THERE'S NOT
OFTEN A MAGIC
CURE, BUT THERE
MAY BE A CLEAR
COURSE OF ACTION

STEP ONE:
IDENTIFY NEED

STEP TWO:
CREATE STEPS
(AKA A PLAN)

STEP THREE:
REMEMBER
STEP ONE

THERE IS ALWAYS
ANOTHER OPTION

WHEN THE ANSWER
ISN'T CLEAR, REFRAME
THE QUESTION

IF YOU CAN'T DO
IT ALONE, ASK
FOR HELP

FIND A WAY TO
FIND YOUR WAY

IT'S KIND OF UP TO YOU
TO DETERMINE WHAT YOUR
LIFE WILL BE ABOUT:

ENLIGHTENMENT? LOVE?
POWER? COMFORT?
THERE ISN'T REALLY A
WRONG ANSWER, NOR
DO YOU HAVE TO
CHOOSE JUST ONE

IDENTIFY WHAT'S TRUE
FOR YOU AND THEN USE
IT TO KEEP YOURSELF
ACCOUNTABLE AS YOU
MOVE AHEAD

THERE'S NEVER
A PERFECT TIME

YOU'LL NEVER BE
100% READY

THINGS ARE
CONSTANTLY
CHANGING (BUT
THAT'S OKAY)

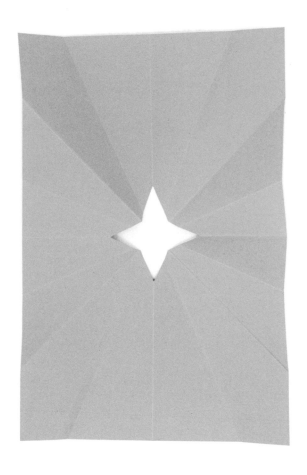

IT ONLY FEELS
LIKE FOREVER
UNTIL YOU GET
TO THE OTHER
SIDE

FINDING YOUR PATH

We think about these big, obvious, defining moments that will manifest in our lives and force us to choose between good and evil or who we are and who we want to be. But in my own life, most of the crossroads I came to were more like city blocks. Do I keep walking full speed ahead, music blaring, checking my reflection in store windows? Do I turn left? Do I turn right? The usual choices, presented repeatedly, block by block. Similar options, over and over again, with varying results.

There are many different ways to get to the same place. It can be easier to visualize a straight path, or an L shape, but zigzagging from A to B can lead to a range of interesting distractions and experiences along the way.

Well-meaning navigators may have mapped the path for you. A shortcut can save time, or a detour might lead to a "can't-miss" roadside attraction. Any set of directions is accurate if it eventually gets you to your destination. Sometimes the directions get confusing and you end up somewhere else, but it turns out to be a pretty good place. Sometimes

you're halfway gone and realize that what you really needed all along was to be exactly where you were before, so you head back, and that's okay too.

There's a stretch of the journey that's one lane only, and so you take the same route as your mother, and your mother's mother, and there is a true comfort in feeling them with you on the way. Despite a direct path in these situations, it's still your choice to keep going. The way forward is always up to us, even when circumstance makes it feel more like fate. Only you can decide to propel yourself further, to venture out beyond the scope of where you are now and where you'd like to be next. You define the speed, you take your preferred method of transportation, and you choose the music.

The road ahead reveals itself, not entirely, but enough to stay focused. A path exists, but the part you know is mostly what's behind you. The way forward is yours to define.

WHAT ARE YOU
WAITING FOR?

Some things are simply a matter of time and patience is necessary. But our time is limited. I can't tell you how much time you have, only that it is finite and at some point you will run out. All the things you wanted to do, all your hopes for the future, all the good you could and would and should do, ultimately you will run the clock and your time will be up.

So what are you waiting for?

There may not be a big, obvious sign from the universe that materializes in your life to announce that IT IS TIME TO DO THE THING. There may not be an outside force that shakes you awake and says ACT NOW OR ELSE. You might not have your come-to-Jesus moment (I don't really know what this means). Your friends might not convince you to take drugs and "find yourself" in nature (I don't really know what this means either). It is extremely likely that nothing at all will happen, and you could live your entire life knowing there's something else or something more, and simply not reach for it.

Change is hard. Things are hard. Changing things is hard. Being the one to stand up and say, "okay me, it's time" is hard. But nobody else is coming to do this for you. Chances are that at a certain point in your life, you will know it's time. That point might be right now. The sign from the universe might exist and it might say YOU ARE HERE *FOR NOW and this might be it.

Calls to action come and go in different stages of our lives. There's young adulthood, where the options are often more flexible and we may have multiple opportunities to set ourselves up for later success, but don't take full advantage. There's your late twenties, where thirty looms over your head and you start to wonder what "transitioning to adulthood" might look like. Then you turn thirty-one, and immediately realize that thirty is literally not a big deal, oh my god, it's so totally fine. There are countless further so-called "benchmarks" that will come and go with as much fanfare as you want, and the entire time there will be new actions or changes to consider. Not all of it is essential, and almost all of it is up to you.

We spend so much of our time just taking care of the day-to-day, keeping afloat, making sure bills

are paid and mouths are fed and family is cared for, and it can often become a blur as weeks become months. Life seems like it's going okay, but it's hard to stop for an accurate pulse check.

How am I really doing right now? What would I change if I had the means? Who would I be if I had a week to reset a few processes I've been running nonstop for years? Where would I go if I could go anywhere? When will I know I've arrived?

There are lots of questions without guaranteed answers, but you can't even try to solve them without time to think. Imagine you're walking through the woods and suddenly arrive at a serene, clear patch where sunlight streams in. You see the trees behind you and the trees ahead of you but for a few moments there is only open sky and moving air and you're just . . . present. You can finally ponder these questions and more.

So find your clear patch. Find your comfortable spot. Find your silence or your ocean sounds or the music that relaxes you (for me it's often Boards of Canada, a vaguely mysterious electronic music duo who apparently know what my brain needs to calm down). Find a pencil and paper, because writing it

down helps when you think you've had an epiphany and the next day it's either nonsense or you've forgotten it entirely. Get to a place where you can get to a place, and then decide where you need to go from there.

There is nobody coming to fix your life for you. Or maybe there is, but it'll be much harder for them than it is for you to do it yourself. This is the sign you were waiting for. This is the signal to do the things you know you need to do, for yourself. You might discover that what you actually need is something you haven't thought of yet, but you won't know until you've really tried a few things to see what sticks.

Commit to taking action and see where that leads you.

It's time to start.

THE END

*JUST KIDDING

SURE, YOU COULD
BURY WHAT YOU
REALLY WANT SO
DEEP INSIDE OF
YOU THAT YOU
ALMOST FORGET
WHAT IT
 EVEN IS

YOU COULD KEEP
GOING AT YOUR
CURRENT PACE,
MASK UP AND
GUNS BLAZING,
AND HOPE NOBODY
NOTICES

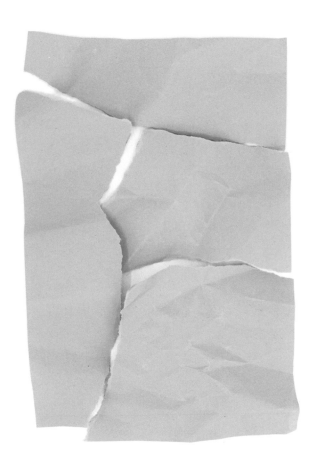

BUT ULTIMATELY
EVERY OTHER
PART OF YOUR
LIFE IS GOING TO
FEEL INCOMPLETE
NO MATTER HOW
MUCH YOU TRY TO
DECORATE OR
DISTRACT YOURSELF

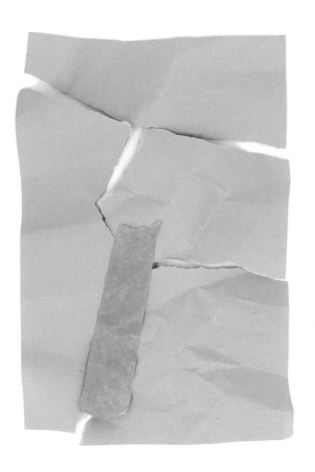

WHAT WOULD
IT FEEL LIKE
TO BE
COMPLETELY
HONEST
WITH YOURSELF?

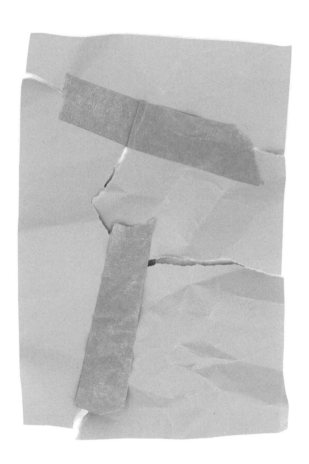

WHAT WOULD
IT FEEL LIKE
TO BE
COMPLETELY
HONEST
WITH OTHERS?

WHAT WOULD
IT FEEL LIKE
TO SEE YOURSELF
ON THE OUTSIDE
THE WAY YOU
FEEL ON THE
INSIDE?

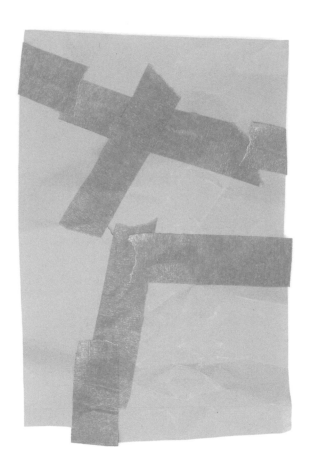

YOU HAVE
EVERYTHING
YOU NEED

PRESS YOUR
FINGER TIPS
TO THIS PAGE

YOU ARE HERE

THIS IS REAL

THANK YOU

ACKNOWLEDGMENTS

I spent a lot of time thinking about whether or not this book, and by extension my art, deserved to exist. Is pencil and paper enough? Writing in the year 2020, I considered what it meant to be truly "essential" to others.

Every time I start to question the value of simple words, one of my own handwritten aphorisms comes back to me, in my social media feed or on an old sticker in a notebook. Appearing at just the right time, words help.

It's my hope that this book can offer some encouragement to anyone who experiences doubt, a reminder for anyone who's been so busy they forgot, and true recognition for anyone whose inner monologue sounds a little bit like mine.

This book evolved over several years and would not exist without everyone who provided encouragement and kindness along the way, whether you realized it was keeping me going or not.

Thank you.

YOU ARE AN <u>AMAZING</u>
& <u>EMOTIONAL</u> PERSON
WHO <u>FEELS</u> FEELINGS

THIS CAN BE ANNOYING
SOMETIMES BUT IT'S
ALSO YOUR SECRET POWER

KEEP BEING HUMAN

ADDITIONAL RESOURCES

Mental Health America
mhanational.org
1-800-969-6642

National Suicide Prevention Lifeline
1-800-273-8255
suicidepreventionlifeline.org

The Trevor Project
1-866-488-7386
thetrevorproject.org

Trans Lifeline
1-877-565-8860
translifeline.org

ABOUT THE AUTHOR

Adam J. Kurtz (aka "Adam JK") is an artist and author whose illustrative work is rooted in honesty, humor, and a little darkness. His books have been translated into over a dozen languages worldwide and his work has been featured in the *New Yorker*, *Adweek*, *VICE*, and more.

A Toronto native, he's lived in six cities and now resides in Honolulu with his husband. Despite an unexpected path, he has so far turned out just fine.

For more, visit adamjk.com or @adamjk.

"ADAM J. KURTZ WANTS YOU TO FEEL BETTER.
ABOUT YOURSELF. ABOUT THE WORLD.
ABOUT THE CREATIVE PROCESS." -ADWEEK

IN BOOKSTORES OR SHOP.ADAMJK.COM